The Native Creative Process

A Collaborative Discourse between

Douglas Cardinal and Jeannette Armstrong

The Native Creative Process

with Photographs by Greg Young-Ing

Theytus Books

Penticton, British Columbia

Canadian Cataloguing in Publication Data
Cardinal, Douglas.
The Native creative process
ISBN 0-919441-26-2
1. Creation (Literary, artistic, etc.).
2. Indians of North America - Art.
3. Indians of North America - Psychology.
I. Armstrong, Jeannette C. II. Title.
E98.A7C37 1991 704'.0397 C91-091743-4

The photographer would like to thank Phil Morton for
the art installation on page 16 and Tony Cheer for that on page 39.

The photographs on pages 24 and 94 are by J.A. Kraulis/Masterfile.

The photograph of Douglas Cardinal on page 122 is by Miller Comstock/Yousuf Karsh.

Design: Robert MacDonald, MediaClones Inc.
Vancouver, Banff and Toronto Canada

Printed and bound in Canada at Kromar Printing
Winnipeg Manitoba

Theytus Books
Post Office Box 218
Penticton, British Columbia
Canada V2A 6K3

Contents

Preface

The concept for a book of this nature came to me in a memorable first meeting with Douglas Cardinal. During the meeting, which was intended primarily to seek advice about a facility plan for Native educational programs being delivered at the En'owkin Centre, Douglas spoke more broadly about his commitment to certain principles central to all his undertakings. He spoke of his need, in the process of his endeavours, to contribute to the healing of our peoples and of all peoples. Douglas also went on to give examples of how he incorporated those principles into all aspects of his work and contact with people; from the concept stage in the creative process, right up to the planning stage and through to completion.

Together with Satish Rao, Douglas' long time friend and assistant, he then showed me his concept design for the Canadian Museum of Civilization and a scale model of the building. I was touched deeply by the symbolic

presence of the principles of which he spoke and how they were implicit in the design concept.

In conversation with him during that visit and others, I came to realize that Douglas Cardinal was a deeply spiritual individual whose art is an expression of a philosophy which I knew to be central to my own identity as a Native person. I became excited by the idea of attempting to somehow capture in words the principles which we both seemed to be trying to articulate in our conversations. I felt that a book speaking of the life principles involved in and articulated through the unique "creative process" used by Native people was one which could make a necessary contribution to the thinking of many peoples. With that in mind, Douglas agreed to have a series of conversations taped over the next two years whenever I could manage to visit with him.

The staff at the firm, Douglas Cardinal Architect Ltd., were extremely helpful assisting us in the development of this book through our often hectic

schedules. In particular, Satish Rao took the time to sit in on all our meetings adding insights which enriched our conversations throughout. Satish provided us with background material, suggestions for illustrations and photography, as well as assistance in clarifying the wording throughout the manuscript. On behalf of Douglas and myself, I wish to acknowledge and thank Satish for his valuable contribution in making this book into a reality.

I consider it a great privilege to have worked with Douglas Cardinal on this project, as well as with Greg Young-Ing whose photography compliments and enhances the text contained in the following pages.

Jeannette Armstrong

Chapter

1

Sacred Earth Walkers

Douglas Cardinal

Technologically advanced cultures dismiss the contributions of the Aboriginal peoples. I believe our contribution can dramatically change everyone's life on this planet. It is imperative that people understand the separate reality of Native peoples and the rest of society. In the past Native Aboriginals of North America lived their lives in harmony with nature and their own nature. It was a way of thinking, a way of being. It was not a way of adversary, of being adversarial to nature and one's own nature. Their ways were to understand human nature and the environment and their part in it. Aboriginal cultures evolved into a way of being in touch with the earth, and experiencing the reality of being part of the earth. For this reason the cultures are based in harmony as a way of being.

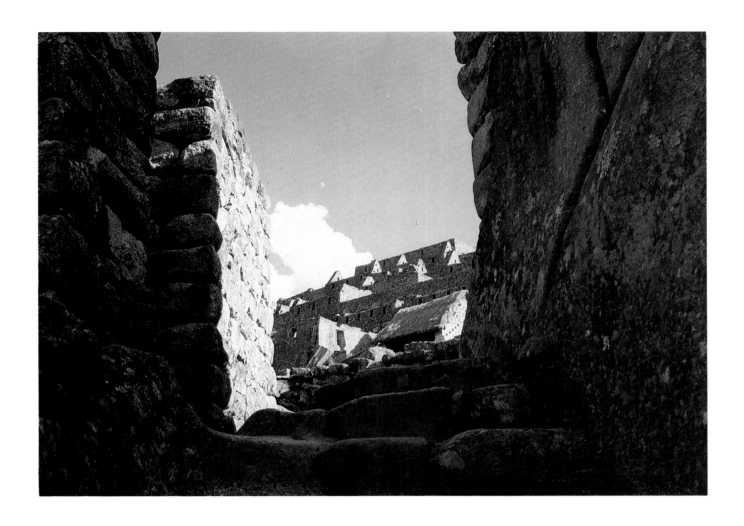

Jeannette Armstrong

The principle from which we examine the Native creative process is an examination of the positioning of oneself from within. We seek to clarify rather than to pursue a comparison of external societal rules which focus on and stress ways to be or not be. An Okanagan phrase iʔ sqəlxʷɬcawt uses a term to describe this principle. The phrase means "our Native way". The term refers to the things we do as specific individuals within our culture as a deliberate part of our existence. It is the deliberate part which is expressed as the creative process and the essence of being human and for which we have complete and utter responsibility. As with the Okanagan, many Native cultures symbolize the human creative potential as the spiritual positioning or the sacred "walking upright earth beings" aspect of thinking animals. The human path "way" thus created is a metaphorical expression of the deliberate progress of human thought.

Douglas Cardinal

A balance does not exist at this time as there is no input by Native people into this world. A sensitivity, a relationship, exists between all beings and all things. Cultures are not being bridged into in a balanced way and as a result each culture has become a victim of the other. Cultures must enhance each other and each has one hundred percent responsibility to bridge. We cannot be adversaries. We create problems when we are adversarial as humans. We eventually become adversarial to nature and our own lifeforms are jeopardized. We as individuals do not need to join the adversarial game. We must face the problem from the midst and the heart of it. It is a challenge to create and maintain harmony in the face of adversity.

Jeannette Armstrong

To the Native, balance is a way of describing how change, which is the natural outcome of any creative process, can be brought about by humans in a deliberate, mutually beneficial pattern as an enrichment process rather than one which is competitive and therefore occurs as a destructive force. An Okanagan phrase which describes this process uses a metaphor **yəyʕat stimʔ put** to present this principle. The translation says simply to make certain that "all things in the world are right". In this simple phrase lies the principle of deliberate non-destruction. A reminder to be aware of and to be protective of the sensitivity and the relationship between all beings and things, including us. The spiders web is a physical construct which many native cultures draw on symbolically to imbed this principle in their storytelling as an expression of the creative process concerned with the connectedness of all things.

Douglas Cardinal

The current image of Native people is that there is no hope for them as Native people in this new world. We have been programmed for self-destruction. We must understand that a programmed inferiority complex means that someone else has written the script. We must understand that as Native people we have one hundred percent responsibility for our lives. In a successful drama we each have total control. We always have this. It is through action or non-action that we allow things to happen. We must put an end to the idea of allowing things to continue and not taking responsibility. This does not mean that we need to accept adversarial methods. We write the script continuously. All actions of all our lives must be conducted like that with no compromise at any time. One hundred percent responsibility.

Jeannette Armstrong

An external search for knowledge which places importance in a materialistic determination of how things relate back to immediate individual human desire reflects an extremely rapid change process. The difference in which change is approached by the Native is perceived to be insignificant as progress. The Native creative process places importance on the internal understanding of our individual selves as a process towards building relationships, moving outward to all other things. This becomes a means of collective long term healthy continuance. This principle is expressed in the open ended kind of societal structures which contain a cooperative symmetry concerned with continuance and yet facilitating the individuals capacity to continuously change and be enhanced in a balanced way. The spiral rather than the circle is used as a fundamental symbol for this.

Douglas Cardinal

Current thought is slowly coming around to the Native way of understanding that the best natural resource is the individual being. In the recent past it has been thought that the best resource has been the use of the natural world. As Native people we have moved quickly from a hunting-gathering society to an agrarian society through to the industrial society and now to the information society. It has taken fifteen thousand years for the dominant cultures to go through this process. It is the information society and the resources of the knowledge we have in living in harmony where we can fully contribute and achieve our full potential as human beings. I see that the hunter-gatherer remains in the creative domain. It is the information society that is without the understanding necessary for us to achieve our full potential as creative beings.

Jeannette Armstrong

Native peoples, as a result of contact, are making extraordinarily important discoveries in their on-going survival through the continuous search to retain and apply the principles of cooperation inherent in the Native creative process. Cultural achievements of Native people are metaphorical footprints of this search to reinforce and reflect this integrity in their lives. Douglas Cardinal's buildings are monuments to the successful outcomes of one such search to survive as a Native in a society that seems to thwart any such attempt. The continued successful demonstration by Native peoples that cooperative principles are possible to maintain in a world damaged by adversarial behaviour may be one of the answers essential to human survival.

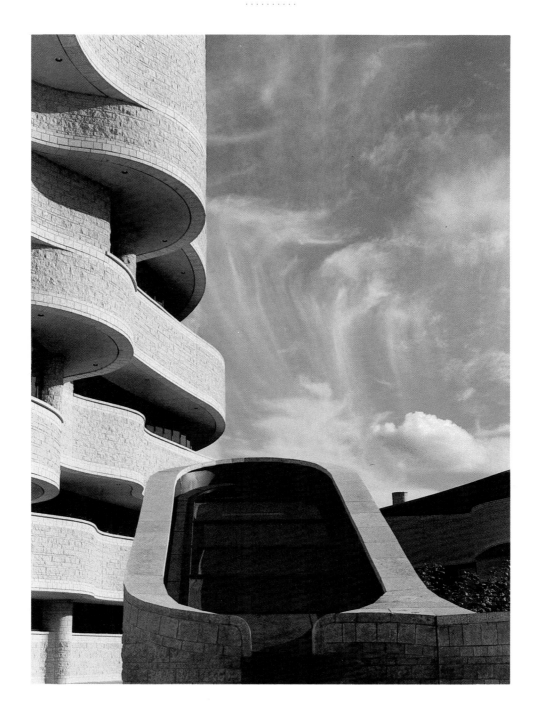

Douglas Cardinal

Moving toward an information society means that we are now moving closer toward the creative natural individuality that we as humans potentially are. We are entering the domain of individual creativity at its highest potential. It is the new possible. We are now powerful as never before. We can take the amassed knowledge of all of mankind, and with that knowledge as a base, standing on that knowledge, we can create a new world based on harmony. It is our responsibility. It is what is needed now in this world.

Chapter

2

Warrior

Douglas Cardinal

I have often spoken about being a warrior from the Native perspective. Such a warrior operates from commitment and a way of being. A commitment is to take a stand for what you believe in. A stand can be all sorts of positions coming from one understanding. It becomes a multi-positioned approach out into the domain of creativity, but remains one stand. Taking such an approach is how I came to be able to build the Museum. It is a willingness to sacrifice everything except your truth, your way of being, your commitment. The ultimate stand is your commitment to do something with your life that will make a difference. I learned from my Native ancestry the power of commitment and the magic of bringing something into being. I learned that we are magical in this undefinable world where anything is possible because we are human beings.

Jeannette Armstrong

An Okanagan word describes the principle of being fully prepared from a multi-positioned approach. The word actually says to qʷíɬmiʔst, which translated, means to "put your most confident self power outward". Collectively, this refers to the physical skills, analytical skills, total spiritual awareness and emotional intuitive sensitivity that should be engaged to face an unknown of any nature. An individual in a deliberate meditative process pulled all capacities together and oneself to act without hesitation or question. Okanagans use this word to advise in all matters of serious consequence. In such an event, to attempt to act without the total self involved, is considered foolish and dangerous. The process of opening oneself in this way allows for a totally new approach to emerge.

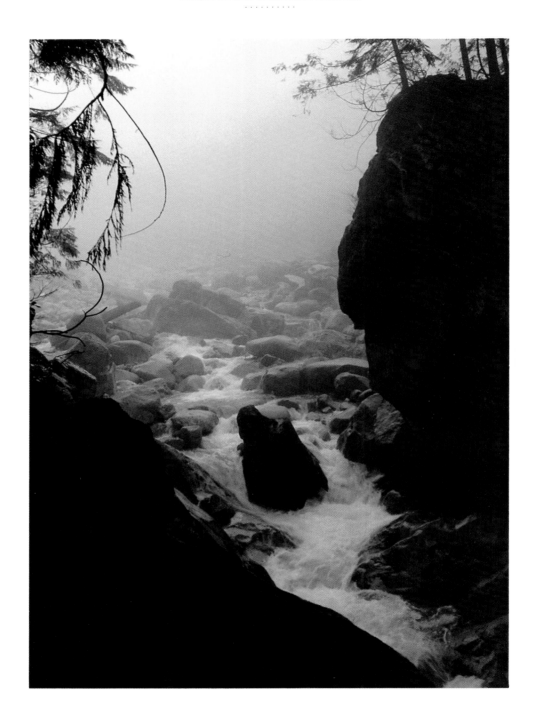

Douglas Cardinal

I had to be taken to medicine man Chief Smallboy's camp at a time when I was very ill. At that camp a lot of time was spent helping me become balanced internally. They healed me with their ceremonies. I was told that the world I had created in my mind was destroying me. I wasn't in harmony with who I was. In the ceremonies, to seek harmony within myself, I had to deal with the things inside that were destructive to me.

Jeannette Armstrong

The magical part of our minds which seeks answers also projects our choices, our actions and therefore their consequence. Our answers become our "world" internally and externally. The spiritual healers in our societies seek to bring the individual to peace with the rest of the natural world and thereby empower the individual with the means necessary to bring about physical healing. In so doing they maintain and bring harmony to the natural world and are gifted in the understanding and teachings of the natural world.

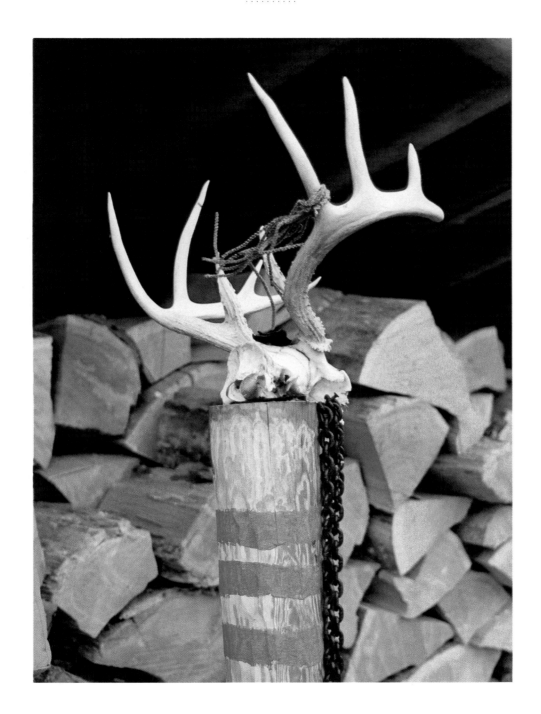

Douglas Cardinal & Jeannette Armstrong

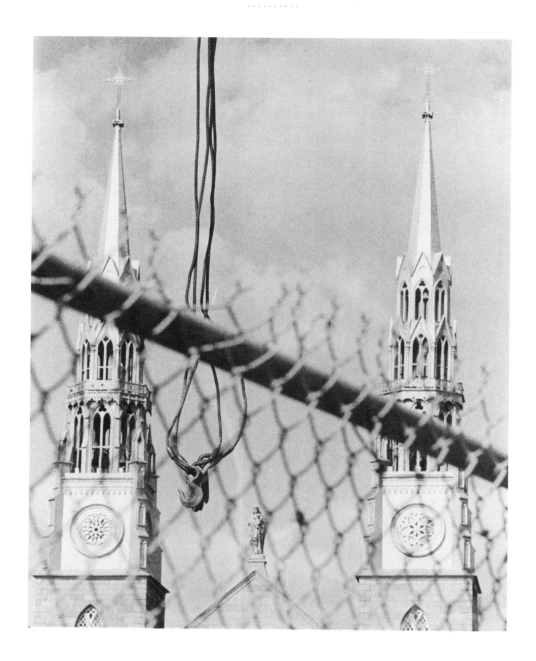

40

Douglas Cardinal

Through the ceremonies I found harmony with myself and nature. I learned to maintain that out there at the camp. But when I left to face the world, I became ill again and again. I couldn't go back and work. I couldn't be a member of this society. It was too hard. I couldn't walk down Jasper Avenue without freaking out. I was like a wild deer. I was ready to go berserk and crash into a glass wall or something. I couldn't sleep in the city. I could sense all the electric fields and the vibrations. I experienced what many Natives feel continuously. It is what happens.

Jeannette Armstrong

The individual in harmony with the natural world celebrates and exquisitely experiences its magnificence. The colours continuously changing, the vastness, the songs of the living, the breath of the earth moving in continuous cycles are all cherished and made totally meaningful to one's existence. My words for this are part of a song which in translation says " Because I am Okanagan on Okanagan land I am beautiful and I am alive". Interference with and destruction of the natural world to such an individual becomes interference with the health of that individual and the destruction of that individual in a very real sense.

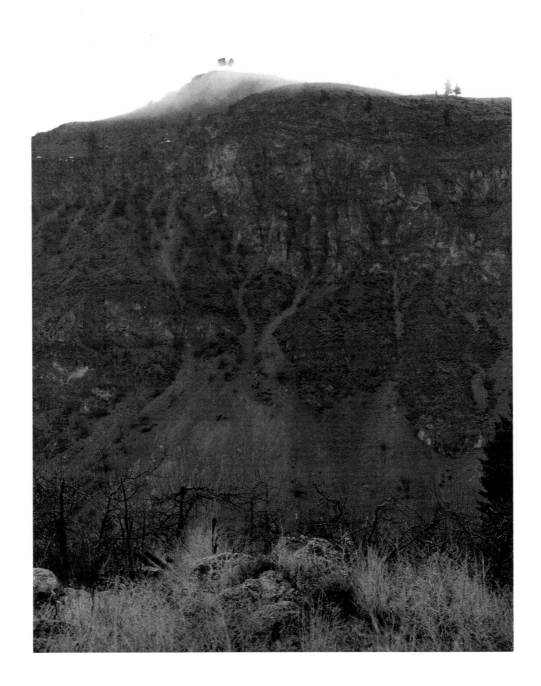

Douglas Cardinal

The difficulty is being able to follow the philosophy of total harmony in what we are doing at all times. I see it as culture shock. An attempt to move from one reality into another. It literally tore me up. I understand the whole thing now. The separate reality of what being a Native is. It is very difficult for any Native who wants to do anything in this society, because to do so separates us so much from who we are internally that they can't be a part of society. It destroys them internally and they get sick. The problem is how to be a Native in this harmonious sense and live in adversity. The problem is to know how to be in harmony and be a Native in the true sense and be able to live and work and contribute to a society that has its roots in a foundation that is totally different, totally adversarial.

Jeannette Armstrong

The ability to bring imagination into physical being through action is the creative process. All action has the potential of tremendous power. The ability to choose the result is the gift of the human. It is a sacred power of the human to choose. A word in Okanagan, x̌ax̌á? refers to the meaningful essence of all creation. The word has been translated to mean "the sacred aspect" of being. This word is applied to humans, as beings with the power to acknowledge or act in ways which seek to maintain the principle of harmony with creation and yet continue to make new choices for survival. We are sacred and precious. In knowing this we become x̌ax̌á?, and cannot escape knowing that all life likewise is x̌ax̌á? and our full creative power as humans is to know this and express this through all actions.

Douglas Cardinal

The answer is in actually being strong in carrying your own world around with you at all times. Your own Native reality. It is then that you can be in almost any situation and function in a harmonious way. It is being a true warrior. It was after I went on a long ceremonial fast that it all came together. It was as if I had two separate bubbles of perception, which suddenly came together into one bubble of perception twice as large. I could see that there were not two separate realities but a oneness of a broader reality. I have to watch at all times so that I don't lose that.

Jeannette Armstrong

The continued survival of future generations depends upon the health of the rest of creation. Protection and survival of the land with its natural inhabitants is a supreme imperative of life. Only the imminent destruction to our land and its natural inhabitants, the people collectively or our individual lives, renders us choiceless. We are x̌ax̌á?, "sacred carriers of peace", and must always maintain this where there are choices. I have had it explained to me that the real translation of the Six Nations word for warrior society is "they are burdened with peace". I see their great Tree of Peace as an eloquent confirmation that such a process continues to withstand assault. Greater imagination and creativity is required to recognize and maintain the long term benefit inherent in the principle of peace than to abandon it for short term victory.

Douglas Cardinal

I have to work at continuously balancing myself. I must look at my role from this perspective of life as a Native or die. It is strict. I know that if I don't follow this way I won't live long. It has been over twenty years now that I have followed this way of being. I know that if I don't do things with integrity, I can't go into the ceremonies. To do a fast or a lodge isn't about you, it is about your commitment. It is larger than yourself. It is I who suffers if I don't do things right. I am always living on the edge in that way.

Jeannette Armstrong

World renewal is a concept which many Native peoples express through their various ceremonial processes. The seasonal or annual practice to ceremonially and collectively incorporate the continuous new realities into the principles of harmony with the natural world is a spiritual journey for each individual. It is a creative journey culminating in action and recorded in the functional and expressive arts.

Douglas Cardinal

You learn in the Native ceremony to come to terms with yourself. You don't try to be superhuman or to be non-human. You accept being human. You embrace it. We are not perfect. You see the human as a loving, contributing machine which has its problems. That is the fundamental thing about all humans. Beyond that, there is the greatness of the human. You see the greatness that we are and then you can see the greatness within yourself. If you see the greatness in yourself, you can see that in everybody.

Jeannette Armstrong

Over the centuries of seeking to live cooperatively within the natural world, Native peoples evolved a body of knowledge contained in the various ceremonies, which facilitated the individual learning process. Such ceremonies seek to unite, acquaint and remind the participants of the underlying principles of creation. The expression of harmony-seeking creative thought-constructs brought forward from such ceremonies become symbolic representation in the arts and are carried out in societal functioning, which in turn changes the world. It is what we refer to as the wisdom of the elders. The human life form alone is given such great creative force and it is such knowledge which makes us both fearsome when we act without wisdom and great when we do. We are the physical expression of continuous deliberate change and therefore extremely important in creation's sacred creative force. We choose the outcome.

Douglas Cardinal

You give power to the contributing side of people if you see them in a positive light. You find that you can work with people by finding alignment in the face of total disagreement. Enrolling them into your vision. Taking people as they are. In that way you can see the Native in everyone and the European in everyone. It comes to a point where you can say that to be a true Native is to be a lot broader in your perspective, to be inclusive in all of the human family; being committed to making a contribution to everyone, not just one people; being a spiritual warrior in the belief that people are great and loving, no matter what culture.

Chapter

3

Eagle Wings

Douglas Cardinal

Knowledge is definite. It is definable. The potential of it is what is vast. You and I can always extend our thinking out there past the definable edge. Out there you can soar like an eagle. Creativity comes from the domain out there, the unknown. Once something is created, it comes into the definable realm of things.

Jeannette Armstrong

To our people, knowledge does not belong to us; we are simply carriers of it. We use the word p?aẋ, which literally translated, says, "to spark so as to cause to light", as in striking a match, to mean to become mind-aware as a human. Knowledge is understood to be only a starting point for the human.

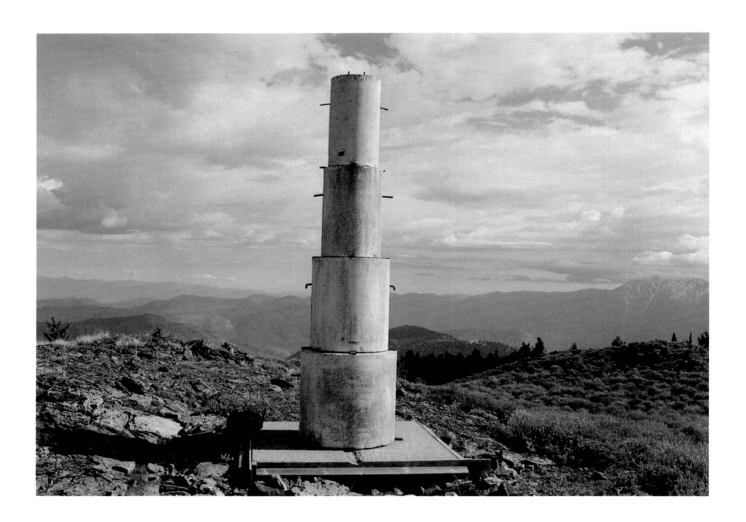

Douglas Cardinal

Creativity is our responsibility, our purpose. One empowers oneself to do the impossible. The more impossible the more creative. The world around us opposes that in a powerful way. The world opposes all change. The nature of a defined set of structured knowledge is that it does not shift easily or automatically. One must expect opposition. To move from the known, you must know that the moment you make a decision in that direction, you totally oppose all and you face total disagreement. It is at that moment that you jump out there in a creative sense. To do otherwise is not new. It is not creative, but simply a shifting of pieces.

Jeannette Armstrong

The Okanagan divides the order of human existence into four main activities. The primary endeavour is related to all things required to stay physically alive (**iʔ scxʷəlxʷáltət**). The next is related to learning and incorporating in living as much of the laws of the external natural world as possible (**iʔ stəɬtáɬtət**). The third primary activity (**iʔ sk̓əɬtr̓ár̓tət**), to perpetuate human life, depends on the success of the first two. The fourth (**iʔ sqəlxʷɬcawtət**) is to do spiritual acts which celebrates and enhances and contributes to the first three activities and pushes out into the unknown. We use our **spəxtáxt**, our mind-awareness, in different ways to do all four things. However, with the fourth, which is the creative process, we deliberately relinquish as much mind-awareness as possible without interference with the first three.

Douglas Cardinal

In the realm of the known, people strategize upon and manipulate the information that they have. The results are what dictates structures of all kinds. The results are what makes laws and customs. Think what would happen if you were to become unpredictable as to your reaction to the essence of those structures. Therein is the essence of Native people in their creative approach in its best sense. Creativity doesn't come from knowing the answers but in being willing to not know and to find out. Thus, failure is always possible. We fail. We make mistakes.

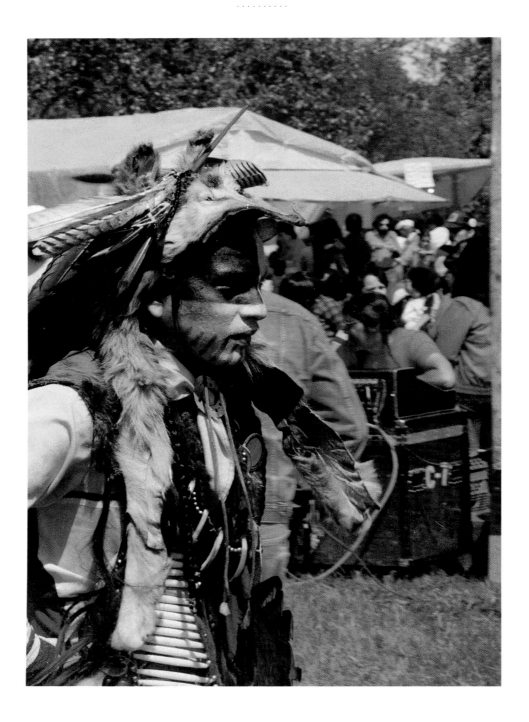

Jeannette Armstrong

In order to move outside of custom in a harmonious sense, many native peoples have created pathways to allow for non-destructive change. The custom of training keepers of our customs through societies requires a rigorous discipline to ensure continued balancing of the individual within the four main activities, with the health and life of others and all else being priority. Full creativity in any given area thus pre-requires the fullest knowledge available about that area and its impacts on others.

Douglas Cardinal

Our handicap is not in failing; it is that we have such a marvellous brain and we remember failure and the danger of it. We have this tremendous knowledge of our mortality. It is mortality which comes up into your face and causes fear to change. So you build up things around you to ground you. You stay in the nest, in the known realm. The fear conversation in your head keeps you from kicking off, out of the nest, keeping you from finding out how great is the feeling to be free, to fly, to soar.

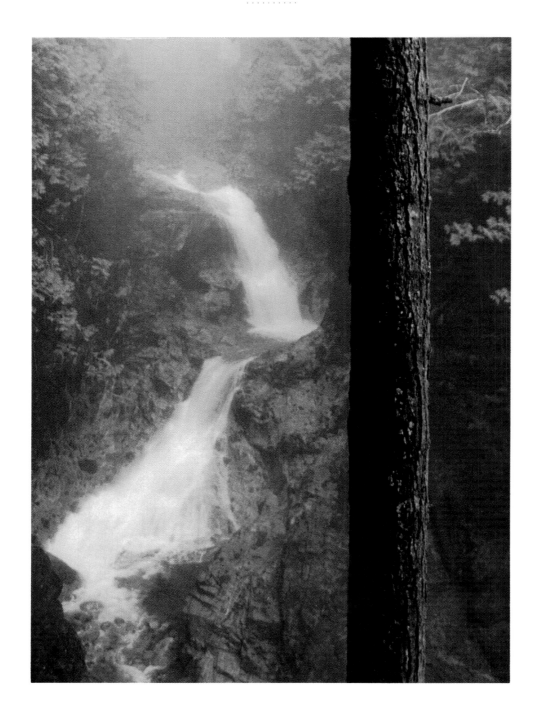

Jeannette Armstrong

One of the elements of the vision quest, as practised by many Native peoples, is the confrontation of one's own mortality. It is explained that the only way to see fully, see one's own mortality and how all prevading it can be, is to abandon it. In such a strictly guided process, developed over many centuries, the Native is said to approach full human potential.

Douglas Cardinal

The Native rituals teach that death is a part of nature. It teaches that mortality is necessary so that others may experience life. Death is a transition from one life to another life. Life is therefore precious in the scheme of things. In that way lives given to you are precious. It is when you do create something, when you do make a contribution, that you come to a realization of the immortality in that. At that moment you realize you are in a dance with chaos.

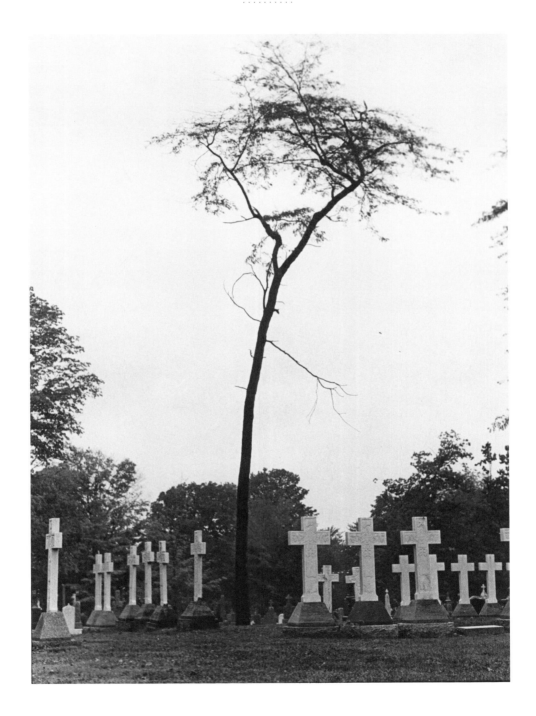

Jeannette Armstrong

Creative acts are continuance links. Consciousness continues and knowledge continues unfolding from one generation to the next. The immortal spirit and mind of the human exists only as long as the fragile physical human life form exists. Our people refer to this collective human past and present as "the old one who speaks to us all". The old one is present in all that we share as human beings. It is present in our wonderful variety of arts, our languages, our ceremonies, our customs and our histories.

Douglas Cardinal

Like an eagle you fly out there on your own with your own abilities. You swing and soar with the breezes and float higher and farther. You move from one point to another, aware and totally alive, comfortable to be out there past the edge of the known realm, into what is only possible. Always soaring, always vigilant from a thousand positions, never afraid, always catching the slightest breeze that will lift you. If you only go into your head and let the world disappear, even momentarily, you end up falling or bumping into something. If you stop being totally aware out there then you will fall out of the sky.

Jeannette Armstrong

The experience of synchronizing with all-time and all things and yet maintaining and glorifying in the creative use of your individual abilities is to be totally human. It is the sacred state of being which is sought by questing and its moments are recorded in the arts as footprints on a pathway.

Douglas Cardinal

There is power in every individual because there is power in the word. Humans are very powerful in this way. To turn the realm of thought, which is abstract potential, into a thing in the physical world, through word, is powerful creativity as a natural act. The essence of creativity in all things is what makes the universe shift. It is to cause something to become from nothing. The word in that way is powerful. When we speak a word we declare something. We create it and then it can be. It can become action. So it is a sacred act. We as humans are extremely powerful in this way.

Jeannette Armstrong

One of the central instructions to my people is to practise quietness, to listen and speak only if you know the full meaning of what you say. It is said that you cannot call your words back once they are uttered and so you are responsible for all which results from your words. It is said that, for those reasons, it is best to prepare very seriously and carefully to make public contributions.

Douglas Cardinal

One person can make a difference. Every act has a significance. Every act is spiritual. Every action you take is the sum of all knowledge before you, and you impact all that comes ahead of you. You owe every action to the past and to the future. It is an awesome responsibility. You reach another sense of power in coming to this realization. You realize that you are a part of something far bigger than yourself. You can then see that wasting your life is a crime. It inspires you to want, to achieve, to be totally used up every second in contributing. It creates immense awareness.

CANADIAN MUSEUM OF CIVILIZATION
MAIN ENTRANCE

Chapter

4

Soft Power

Douglas Cardinal

Native people have made a tremendous contribution to me. I would not have been able to create the museum without it. They can make a major contribution to everyone. Academic training is fine, but if you lack a centre as an artist then creativity is not possible. I have learned from Native people that the most powerful force is soft power, caring and commitment, together. You need that centre to make a contribution creatively. You need to realize its power to make it realize your vision. You can have visions and dreaming but how you realize them depends on caring and commitment. Soft power is more powerful than adversarial or hard power because it is resilient. By its nature, soft power is giving and flexible but strong. It is woman power, female power.

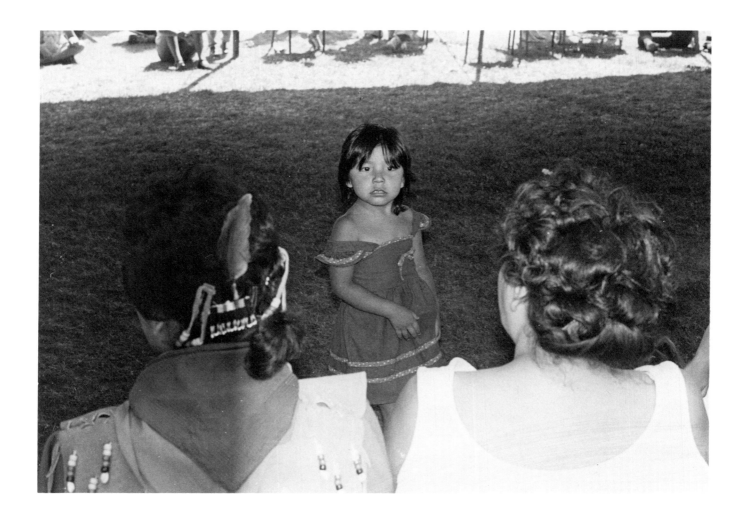

Jeannette Armstrong

The Native non-adversarial approach to life *resonates* pacifism, although it is often mistaken for passiveness. The central discipline to this approach is to maintain the spiritual principles of love for all life, for to abandon them is to abandon life.

Douglas Cardinal

Here is the wisdom of our elders. As an individual you are both male and female. Men and women are very powerful working together. As a man, if you allow yourself to be sourced by women, to be coached , to learn from them, to take the contribution that they are, then partnership is very powerful. As an individual if you don't allow the female to emerge in you then you can go only so far. If you have soft power, you do care, you do have compassion, love, then you can do anything. I have learned these things through the commitments I have made. It makes things happen. It cuts through things like butter.

Jeannette Armstrong

In the Okanagan, as in many Native tribes, the order of life learning is that you are born without sex and as a child, through learning, you move toward full capacity as either male or female. Only when appropriately prepared for the role do you become a man or woman. The natural progression into parenthood provides immense learning from each other, the love, compassion and cooperation necessary to maintain family and community. Finally as an elder you emerge as both male and female, a complete human, with all skills and capacities complete.

Douglas Cardinal

Love is what makes things move. Love is what makes things powerful. You can't order the universe but you can find what the natural forces are in it that you need in order to do things right. You must allow yourself to be comfortable with chaos and dependent on it to get things done. To deliver a dream to reality you must allow yourself to be vision-oriented, using all means positive to be total. You then have the opportunity to bring powerful things to bear in a non-adversarial way, asking for the contributions of all others and things.

Jeannette Armstrong

At the centre of positive creative activity is the desire to bring health and enrichment into the lives of others. To create change mindlessly invites the risk of the kind of destructiveness which could reverberate far into the future. In Native philosophy, creative activity is a deep spiritual responsibility requiring as full an awareness as possible of its sacred nature and the necessity for pure love to be at its centre.

Douglas Cardinal

Aboriginal peoples live in the dream state of vision. As Native people we are trained to bring dreams up into reality, into the real world. As a Native person I am trained to bring out people's visions. I am a dream-maker trained to make people's dreams a reality. I am totally involved in a dream in the making. It is a way for you to view yourself. That is what it is all about. Dreams of what could be.

Jeannette Armstrong

The Okanagan word for ourselves is sqilx^w. Which in a literal translation means "the dream in a spiral". We recognize our individual lives as the continuance of human dreams. We know our lives to be the tools of the vast human dream mind which is continuing on into the future.

Douglas
Cardinal

The Canadian Museum of Civilization is a true monument to our people. I went to the ceremonial lodge and I was given the vision. It is a vision of taking technology and creating something positive with it and maintaining my way of being in doing it.

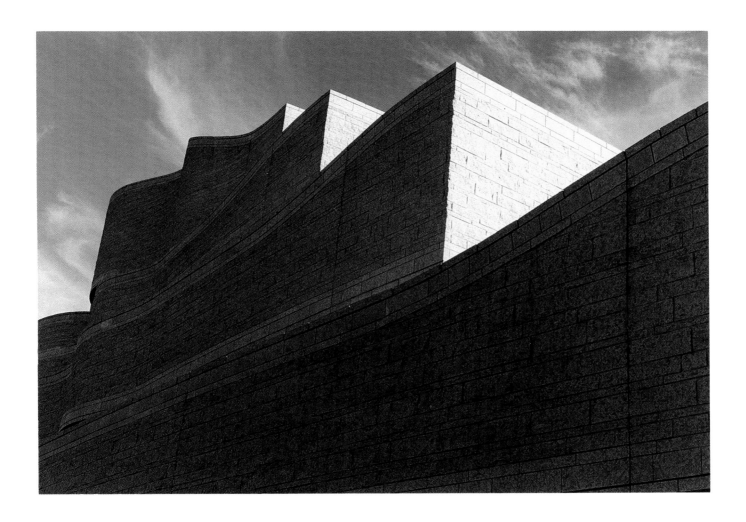

Jeannette Armstrong

The physical contours of Douglas' building and the process by which its aesthetic sensibilities are achieved through the blending of new and old ideas, man-made and natural source materials, through the use of new technology and Native spiritual visioning, speaks eloquently as a magical metaphor of what can be.

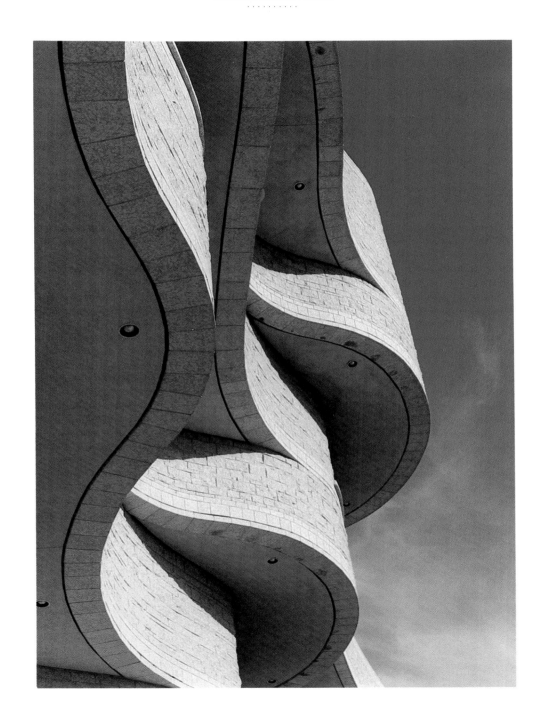

Douglas Cardinal

The vision is that I will make a contribution. In doing so I will see the greatness in every person and see the aboriginal in every person. My vision is to see every person, not as separate from me but as an inclusion in my own perspective as a part of the human family, and to reflect on that. It is how I can serve.

Jeannette Armstrong

Native peoples are contributing the vison of a world which is non-adversarial and a world in which all cultures, all peoples and all life is cherished. It is a vision which I strive toward and which I believe is the intent of creation.

Douglas Cardinal

The vision is that we can contribute to each other. I will represent this by making that kind of contribution. The vision is of a better way our systems, our cities and our families could be. I move toward that always.